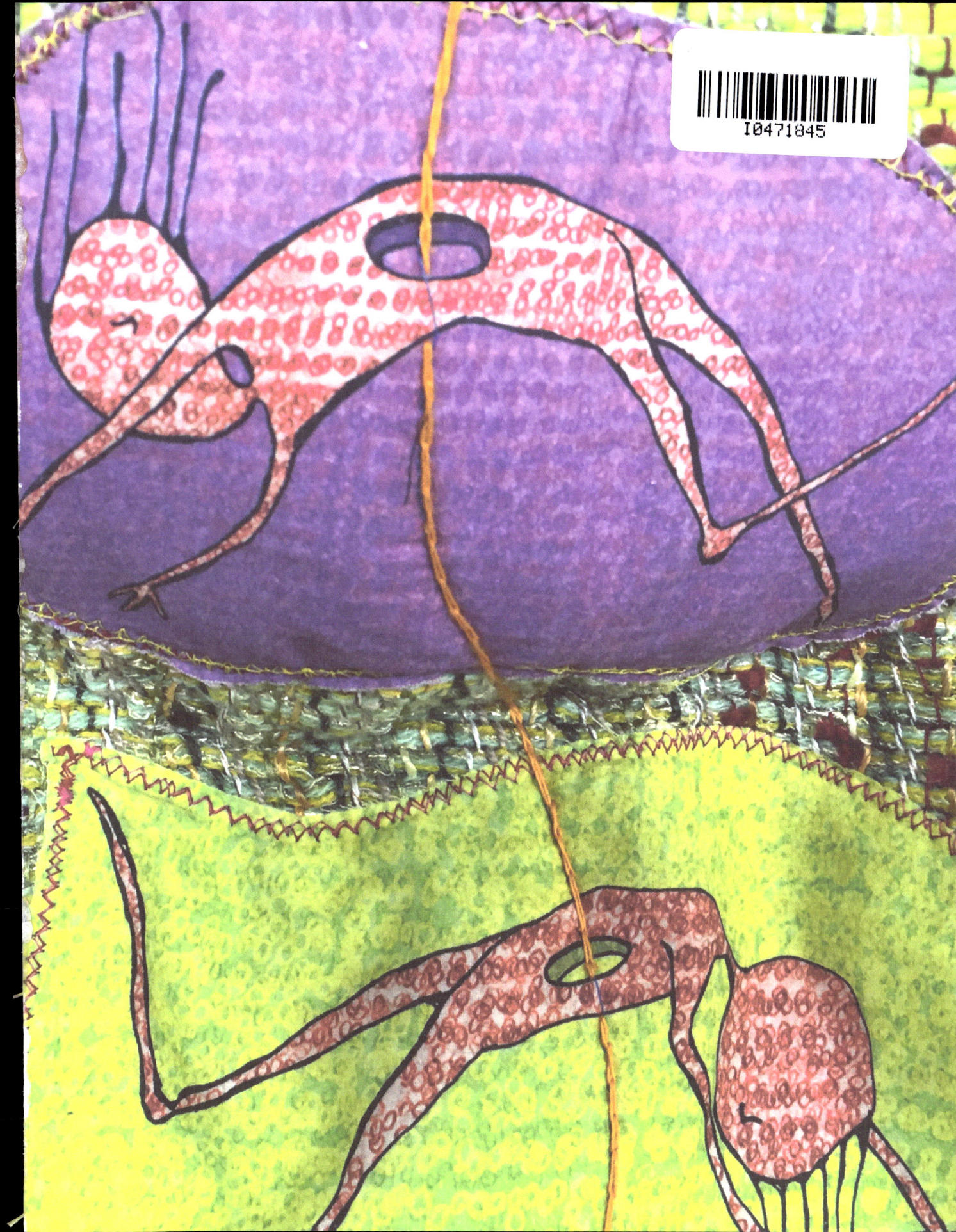

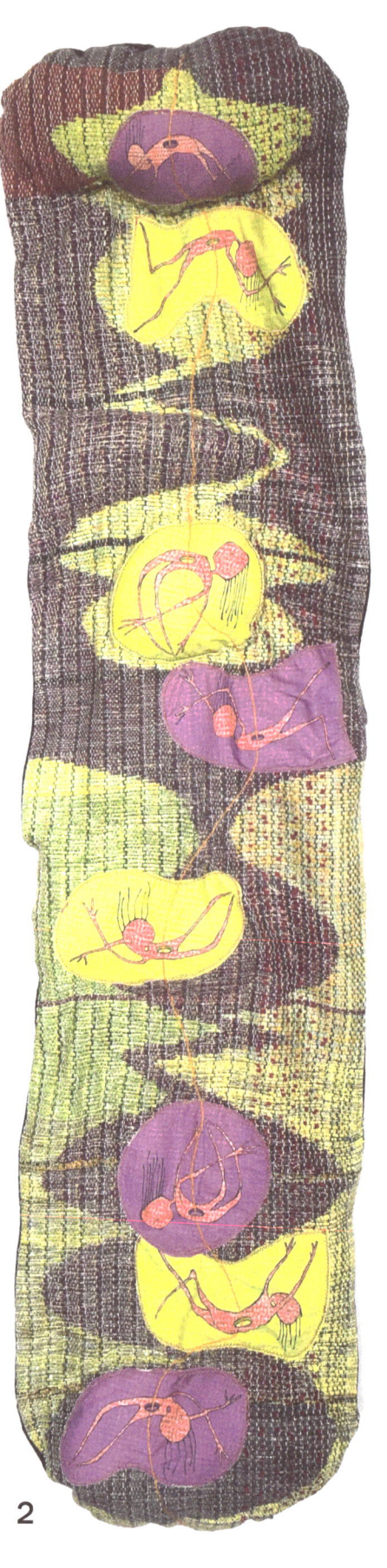

the artist statement for how it feels falling for you

the right side of the artist statement

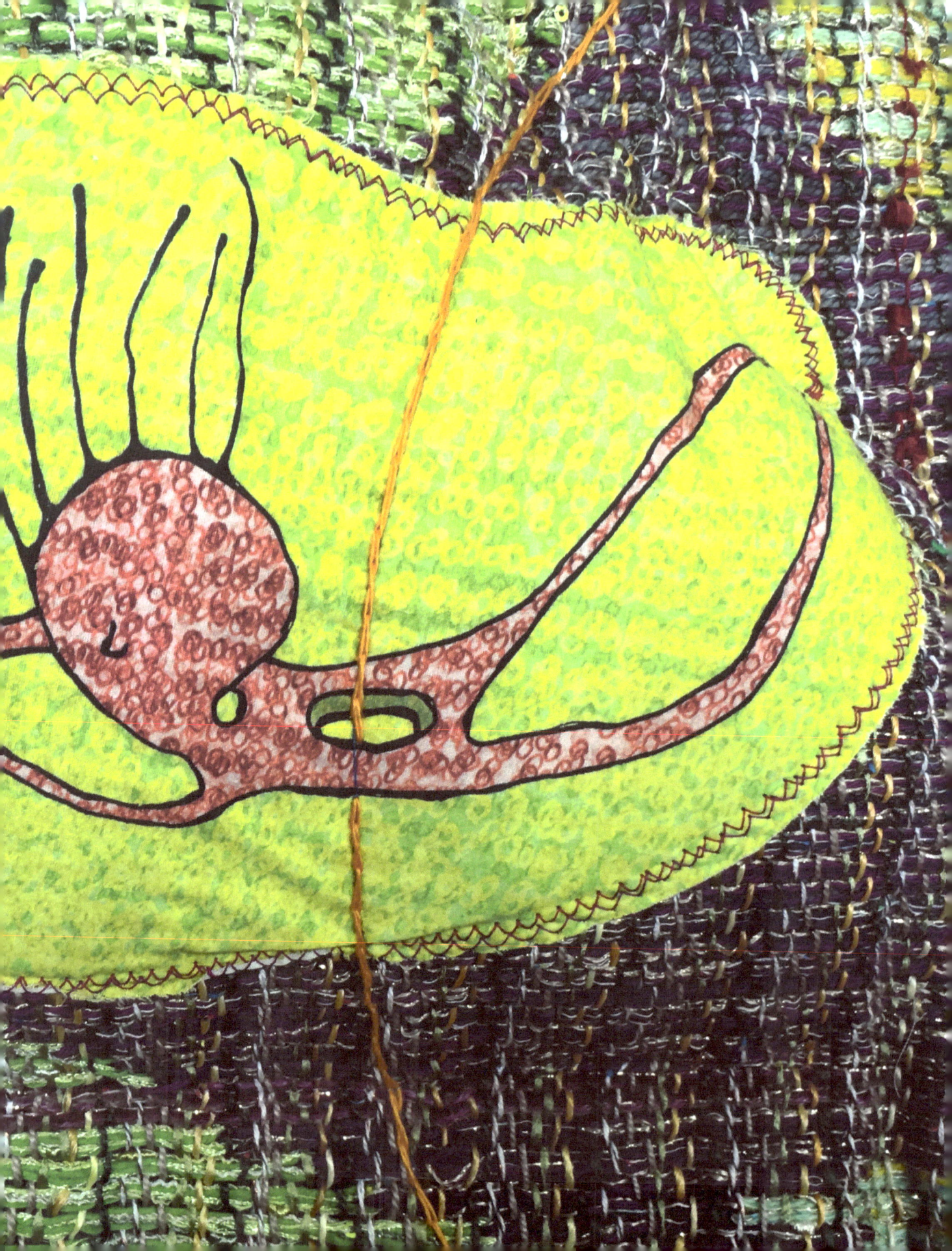

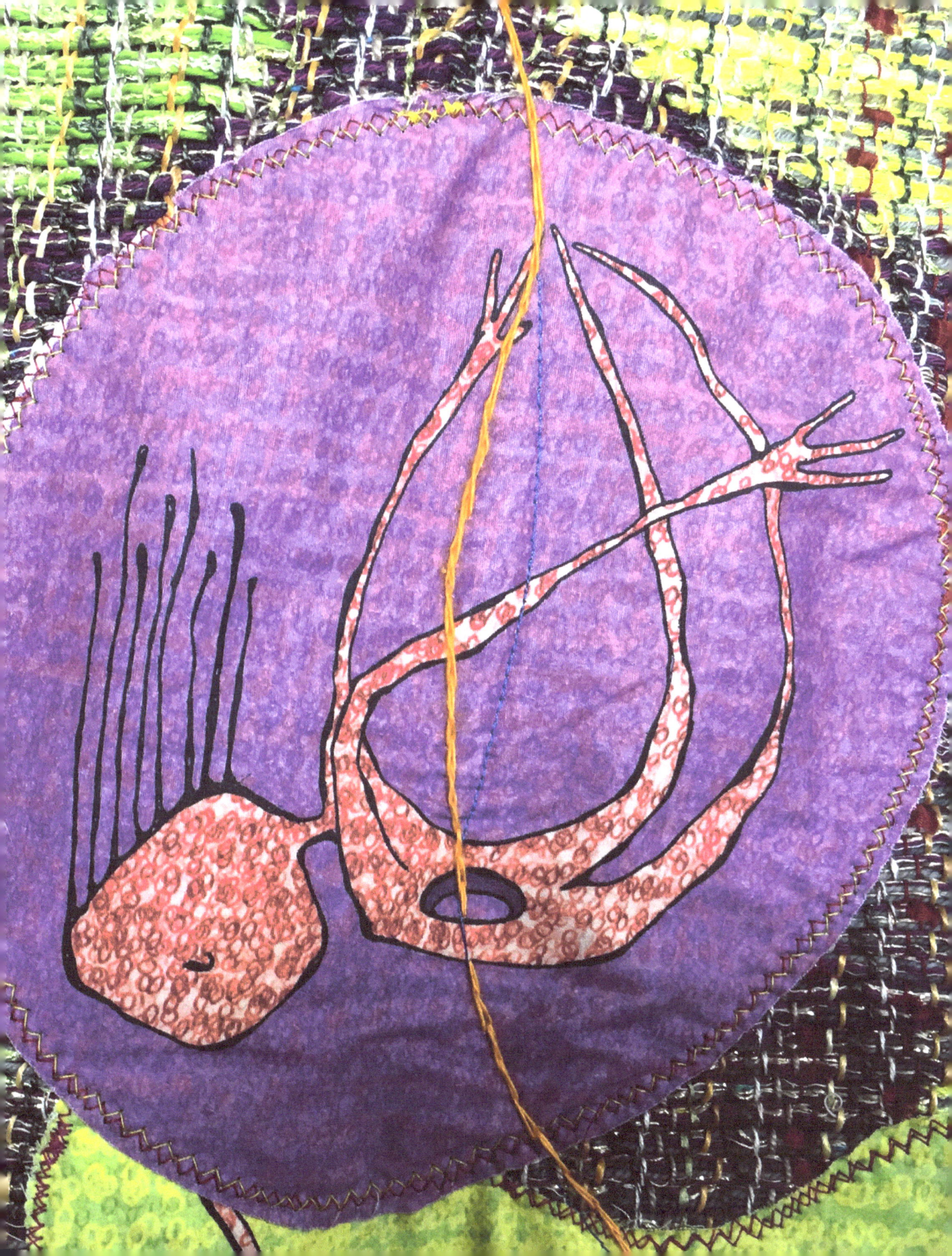

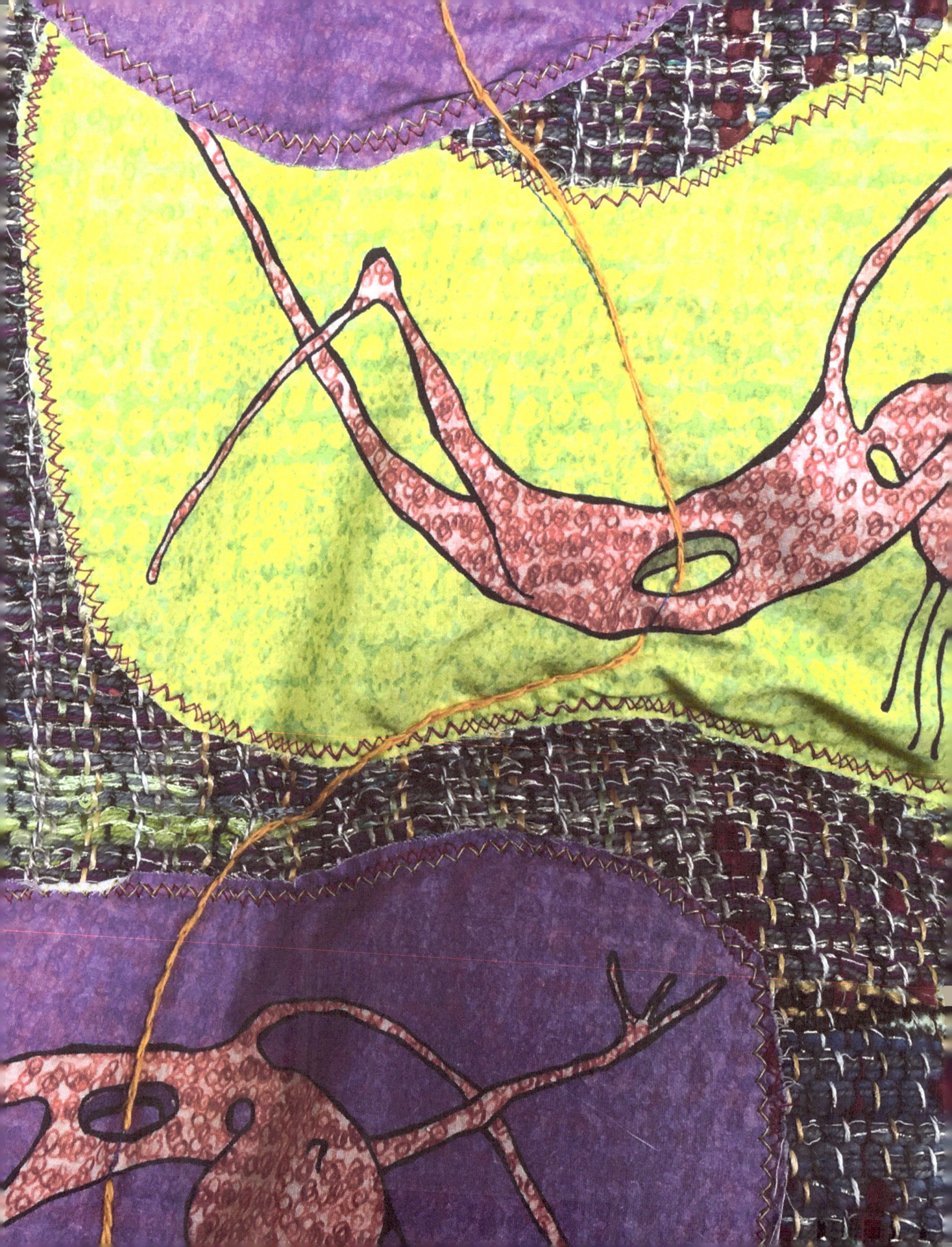

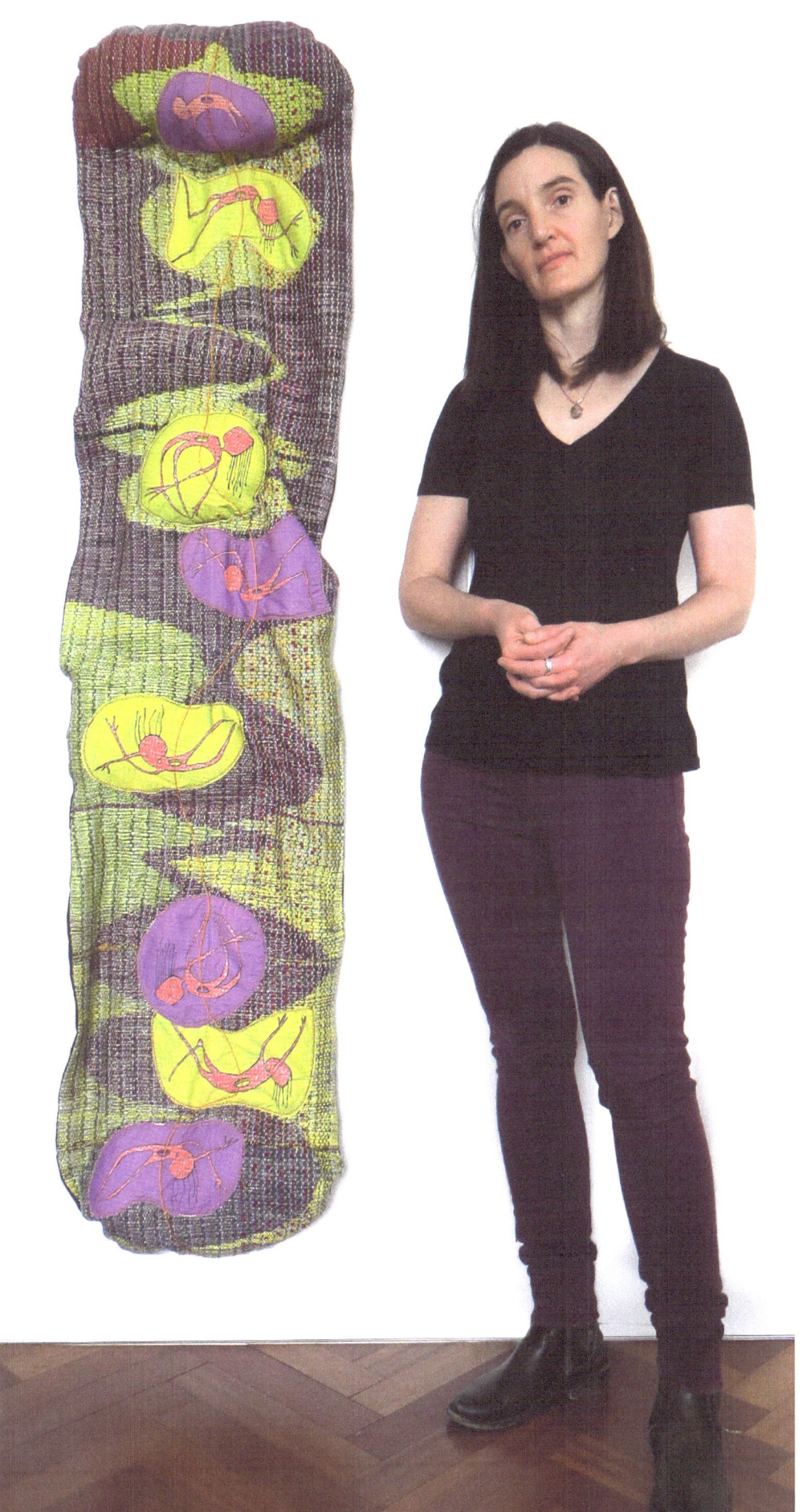

You can't take

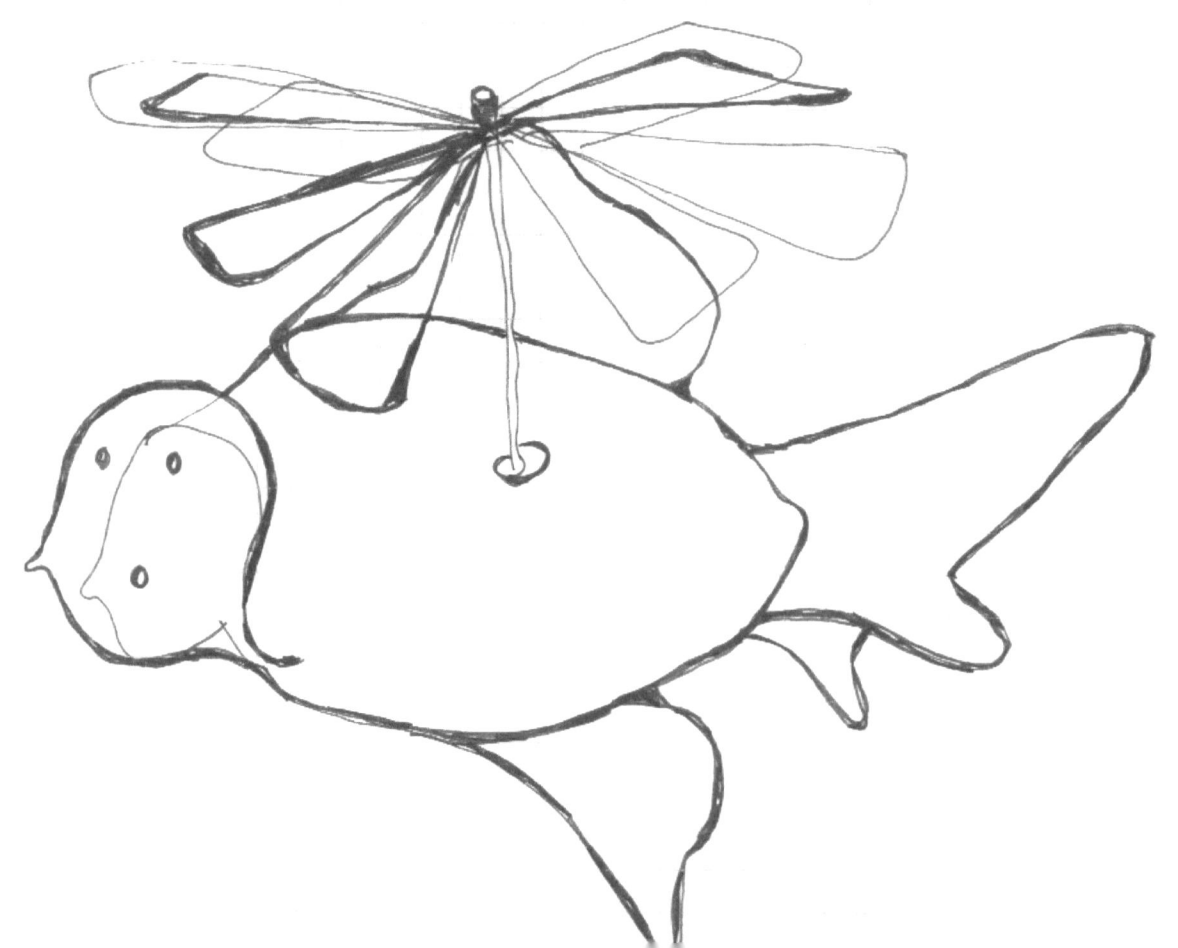

december 1-
2016

this

seriously.

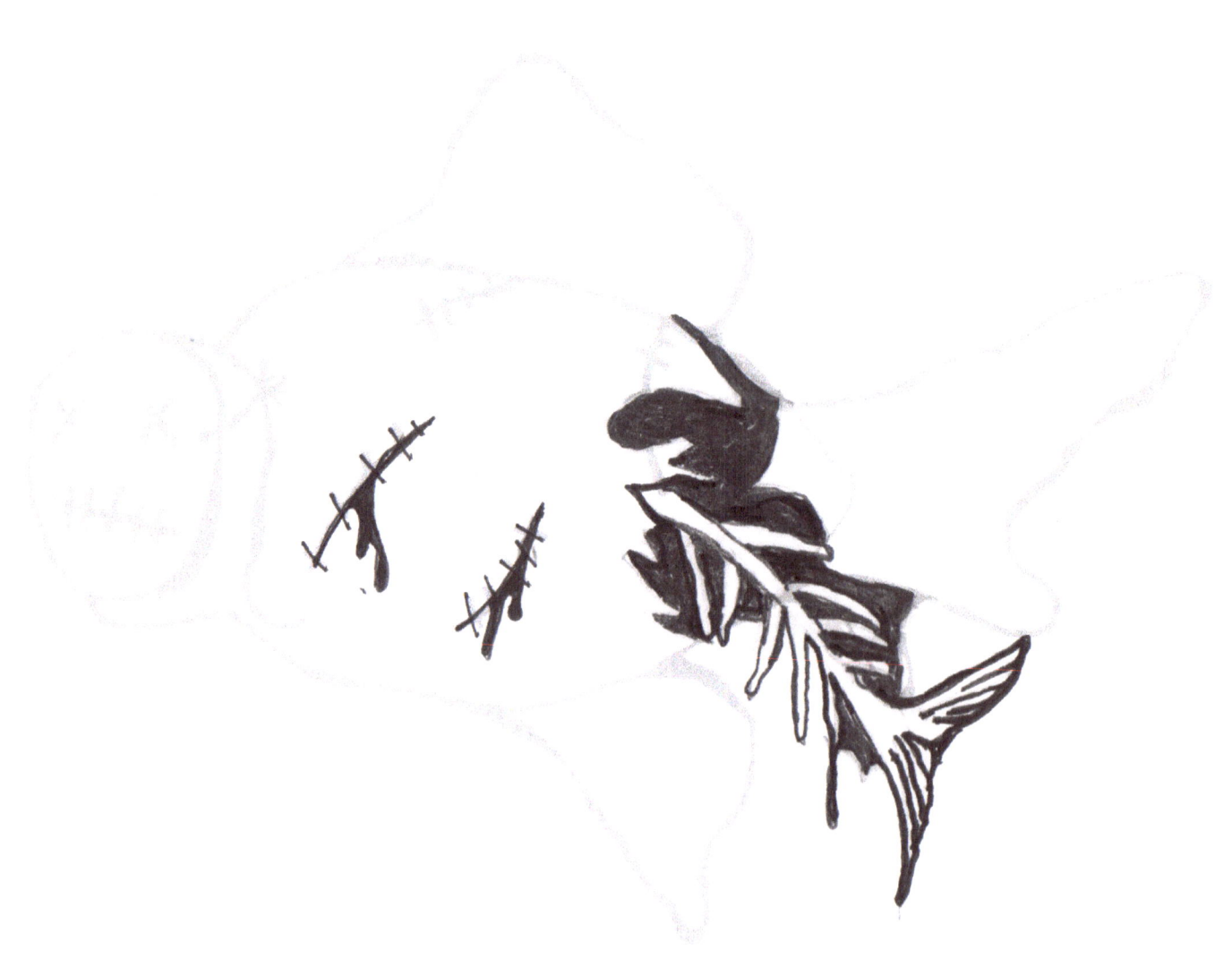

You can't take this seriously.

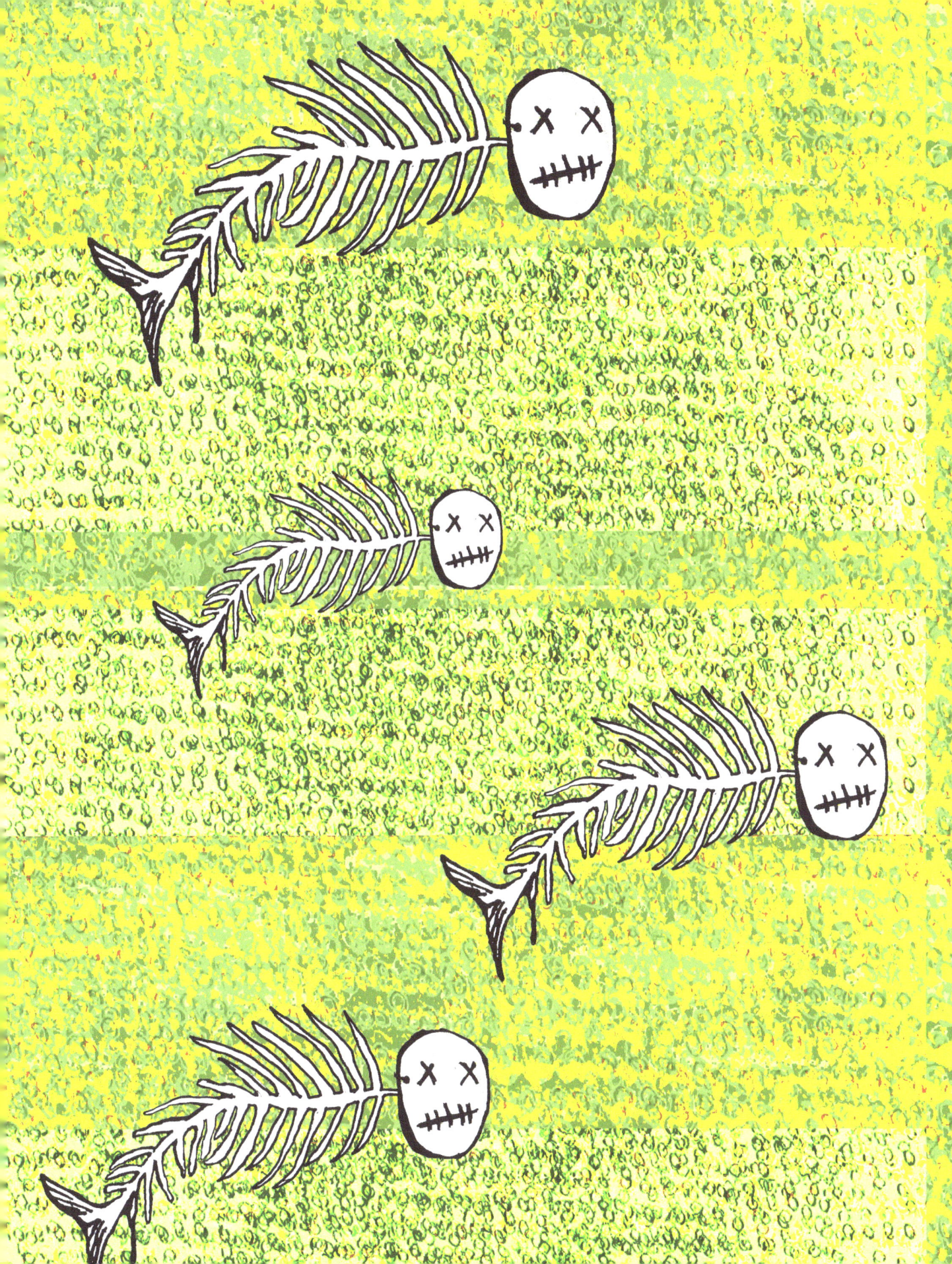

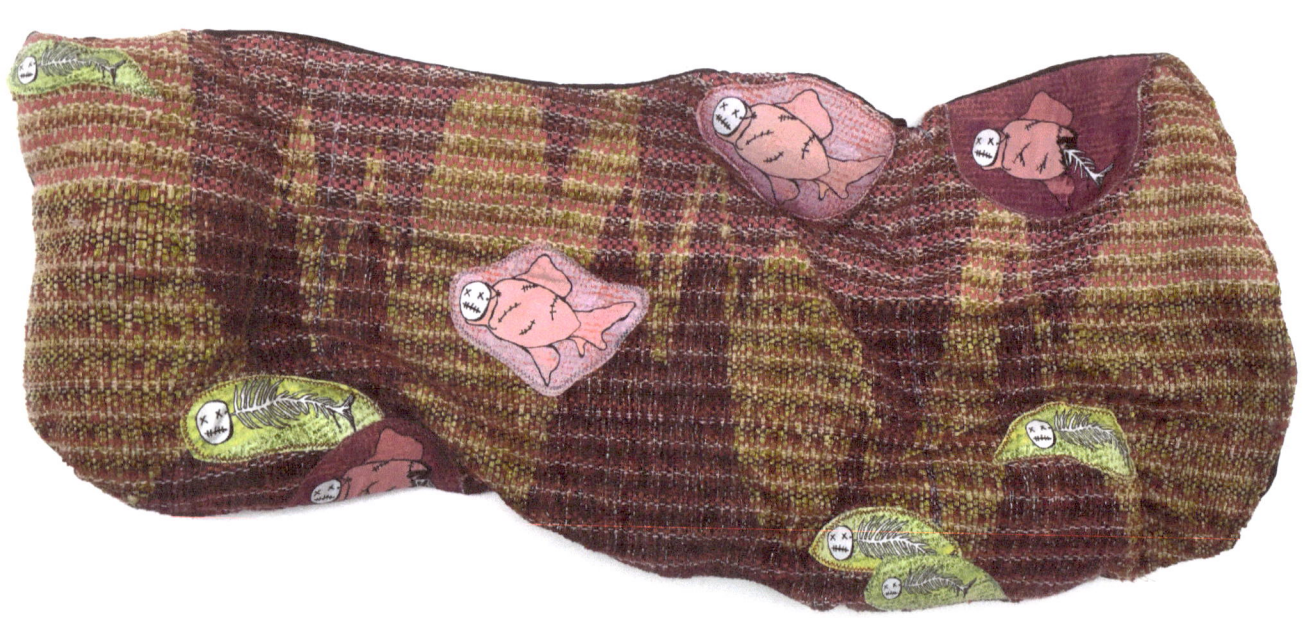

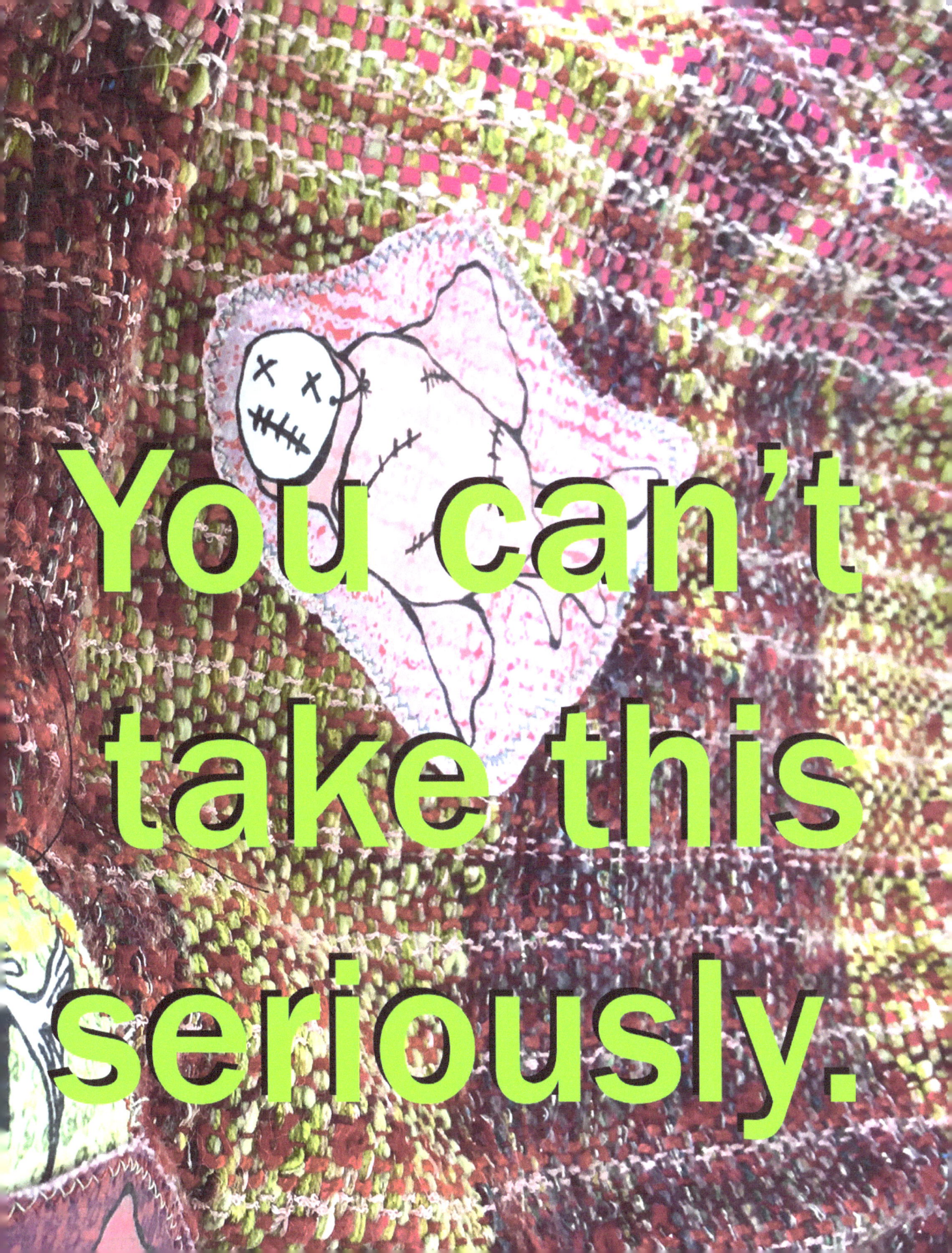

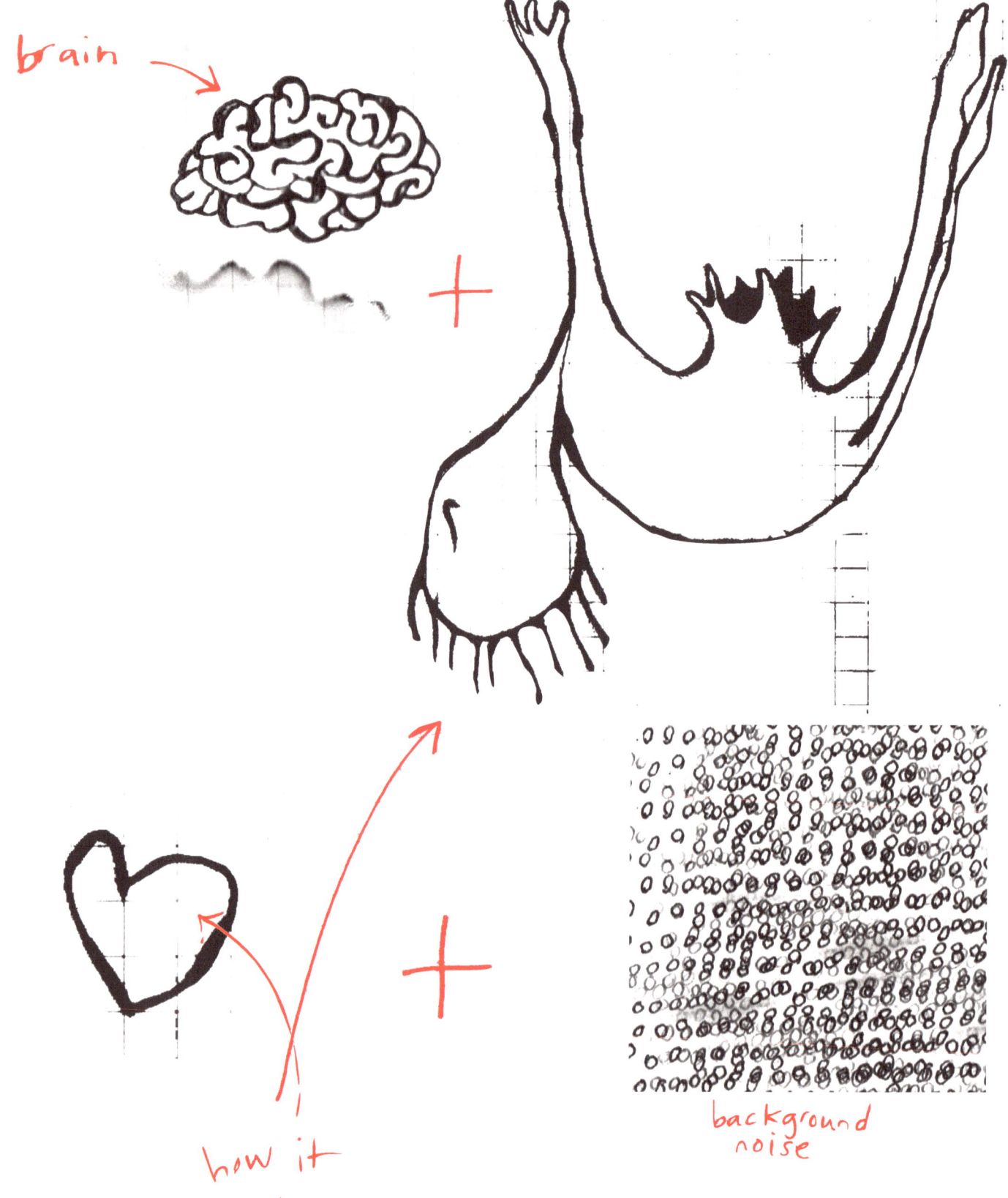

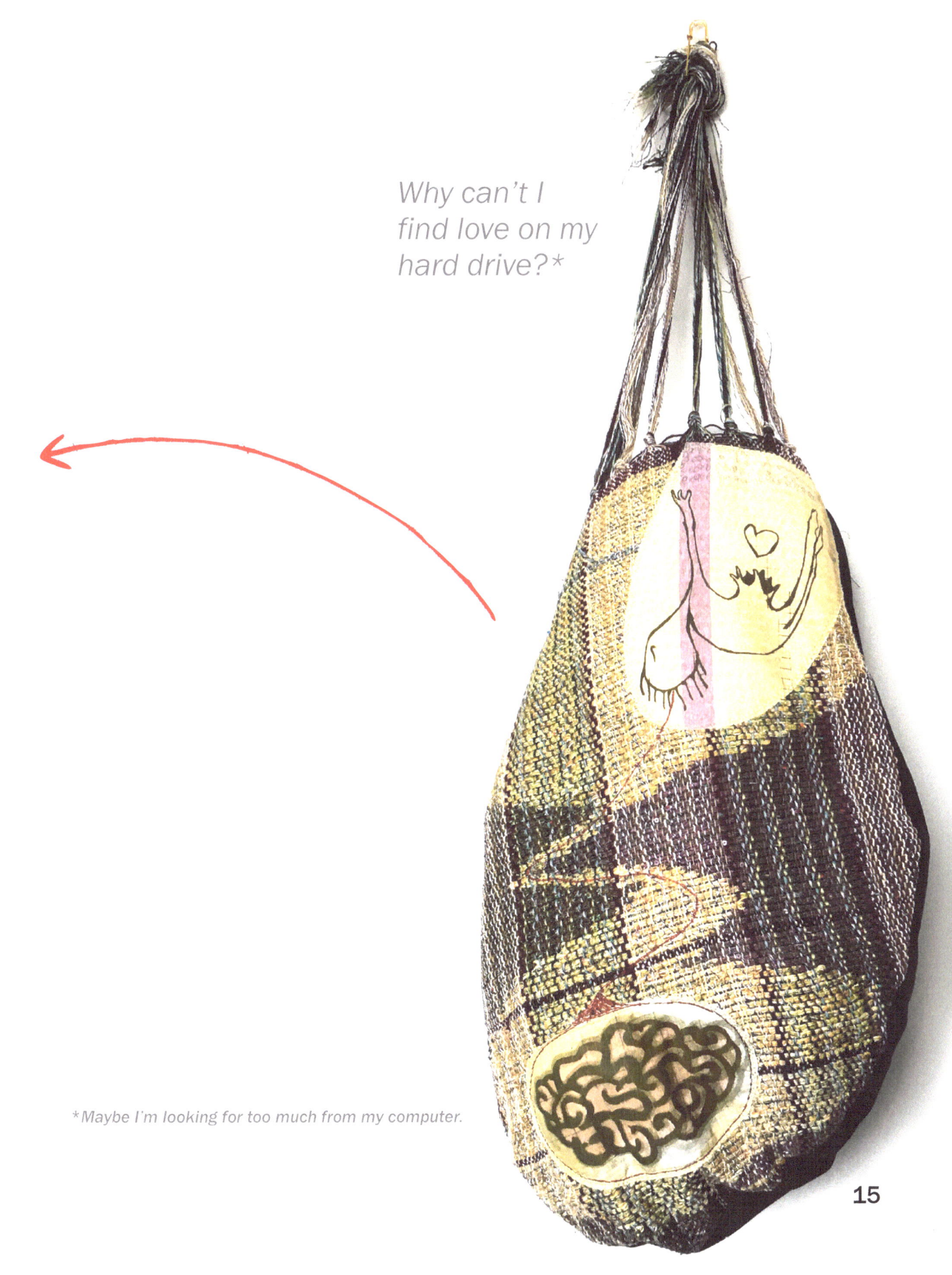

*Why can't I find love on my hard drive?**

**Maybe I'm looking for too much from my computer.*

You weave who you are.

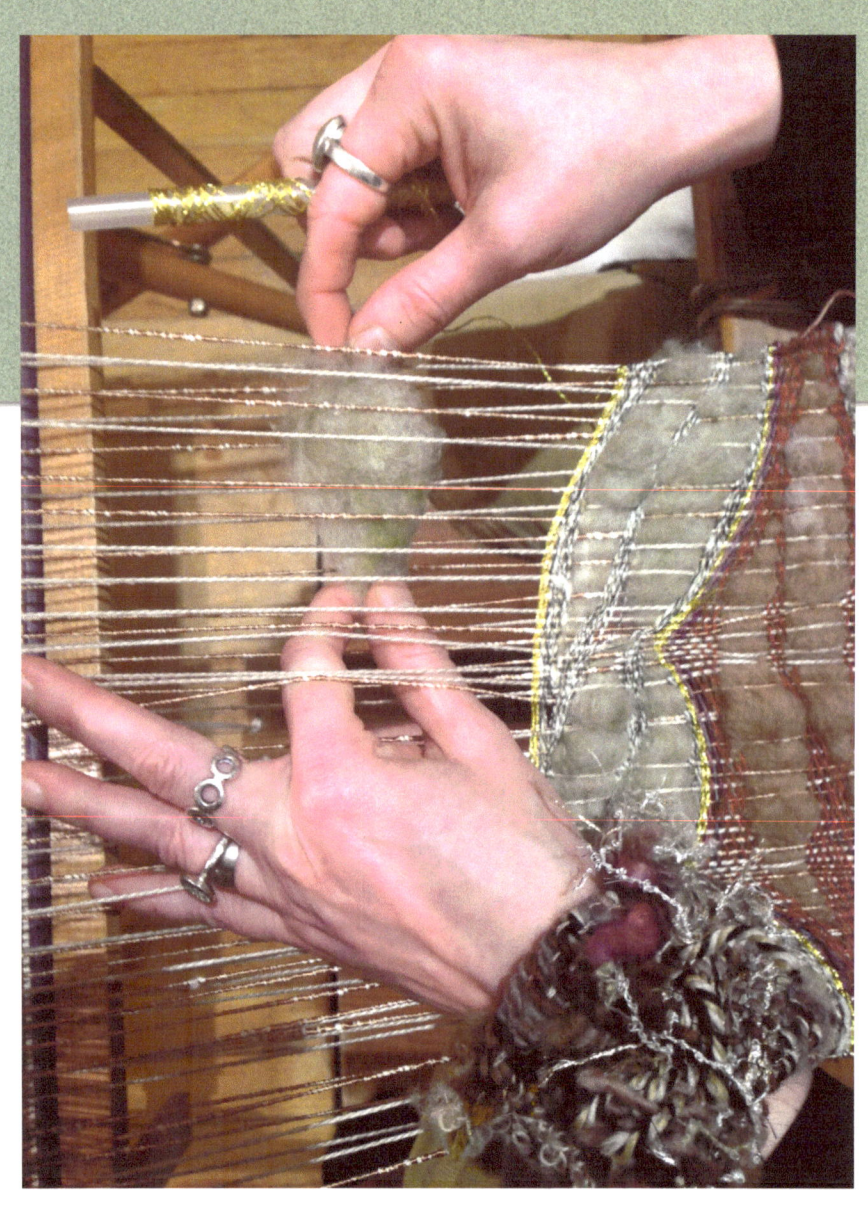

blah, blah, blah, blah

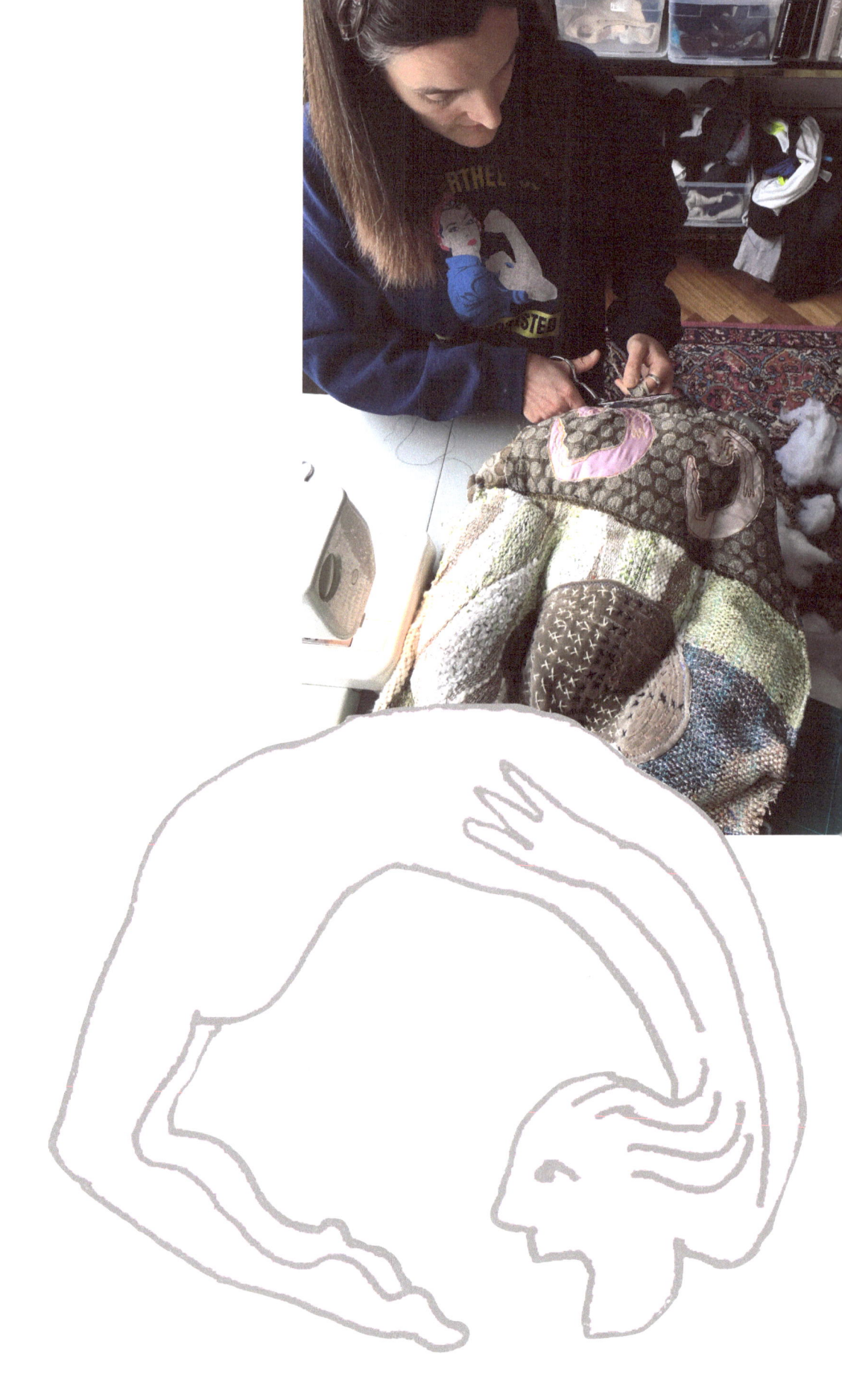

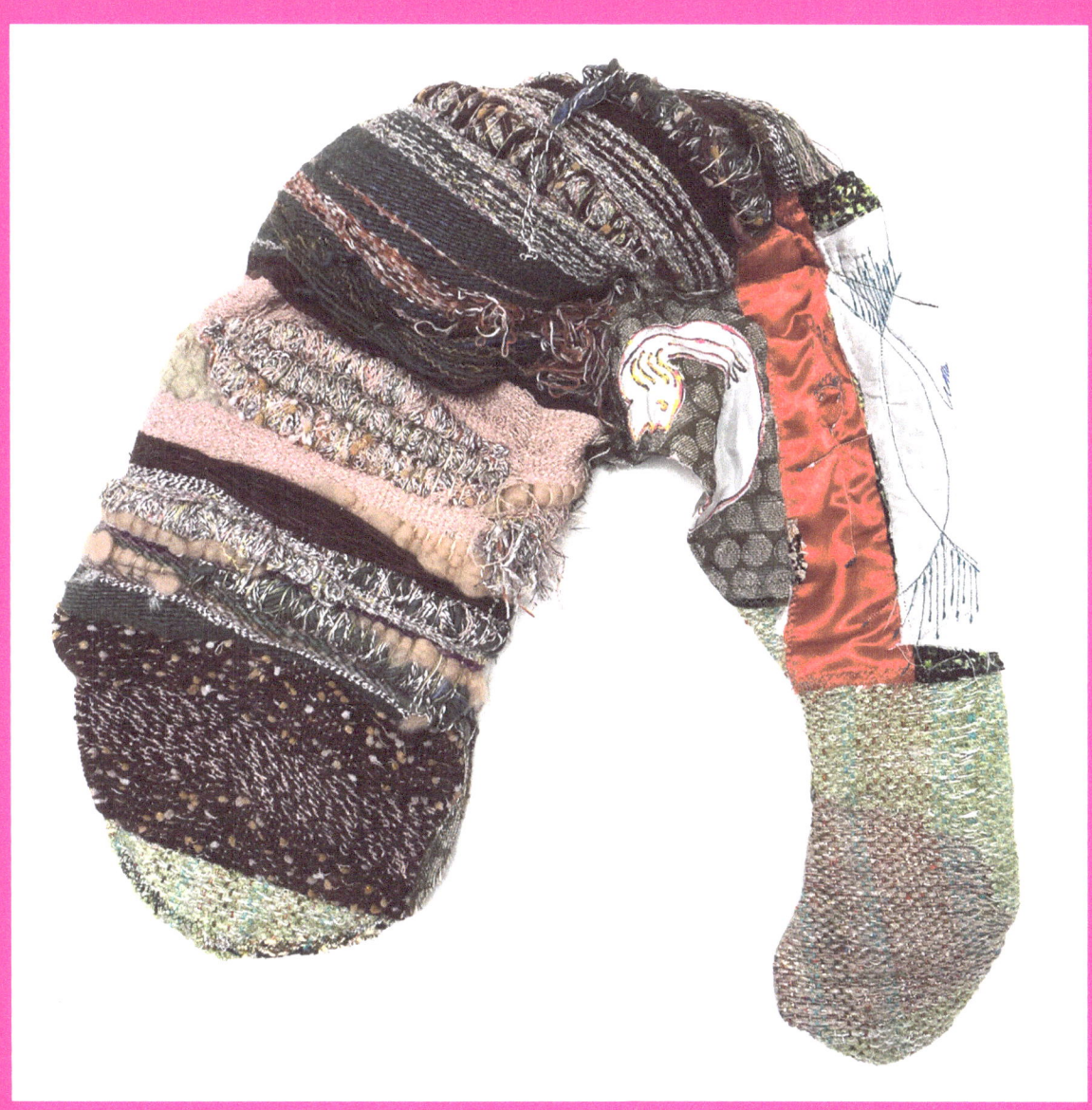

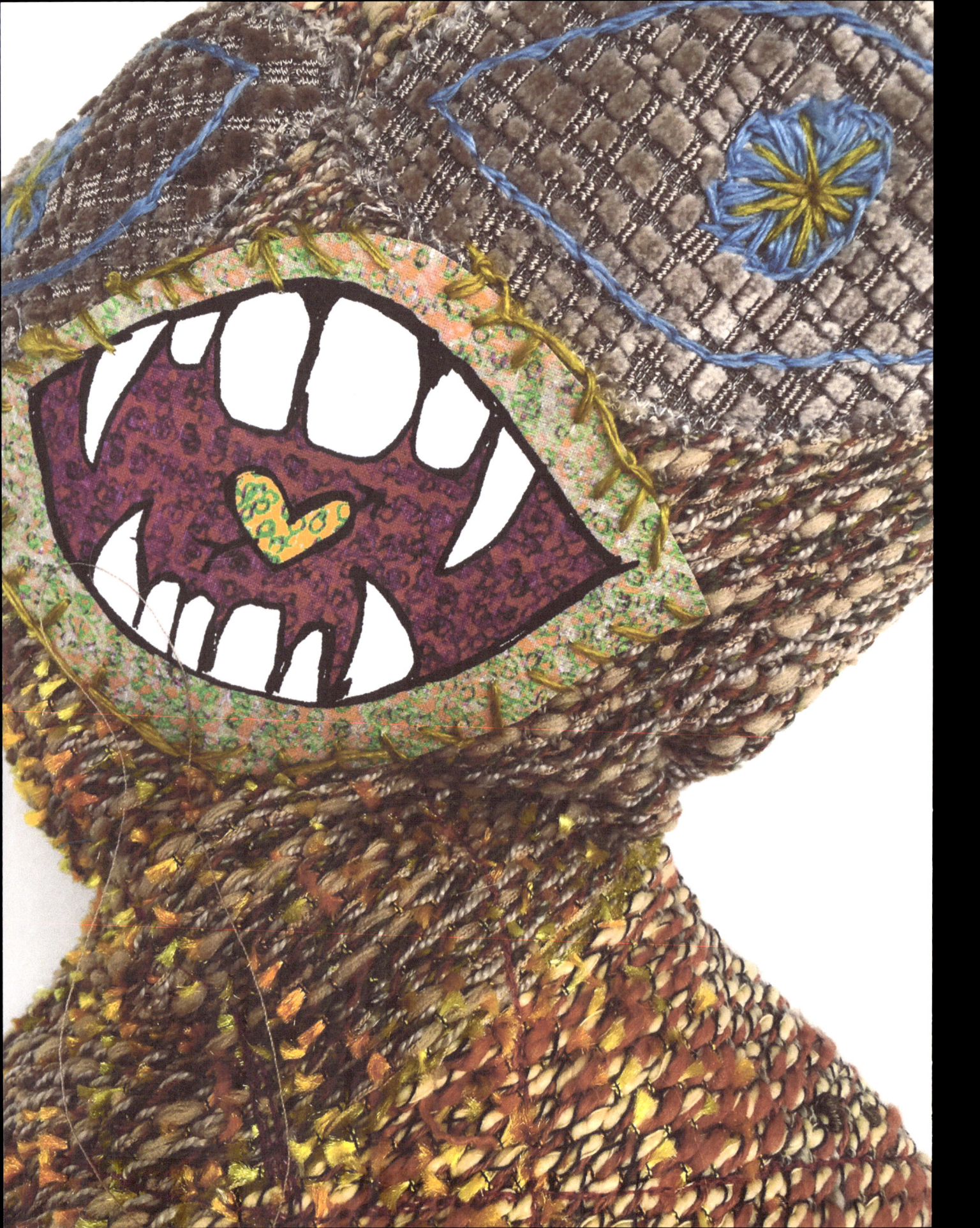

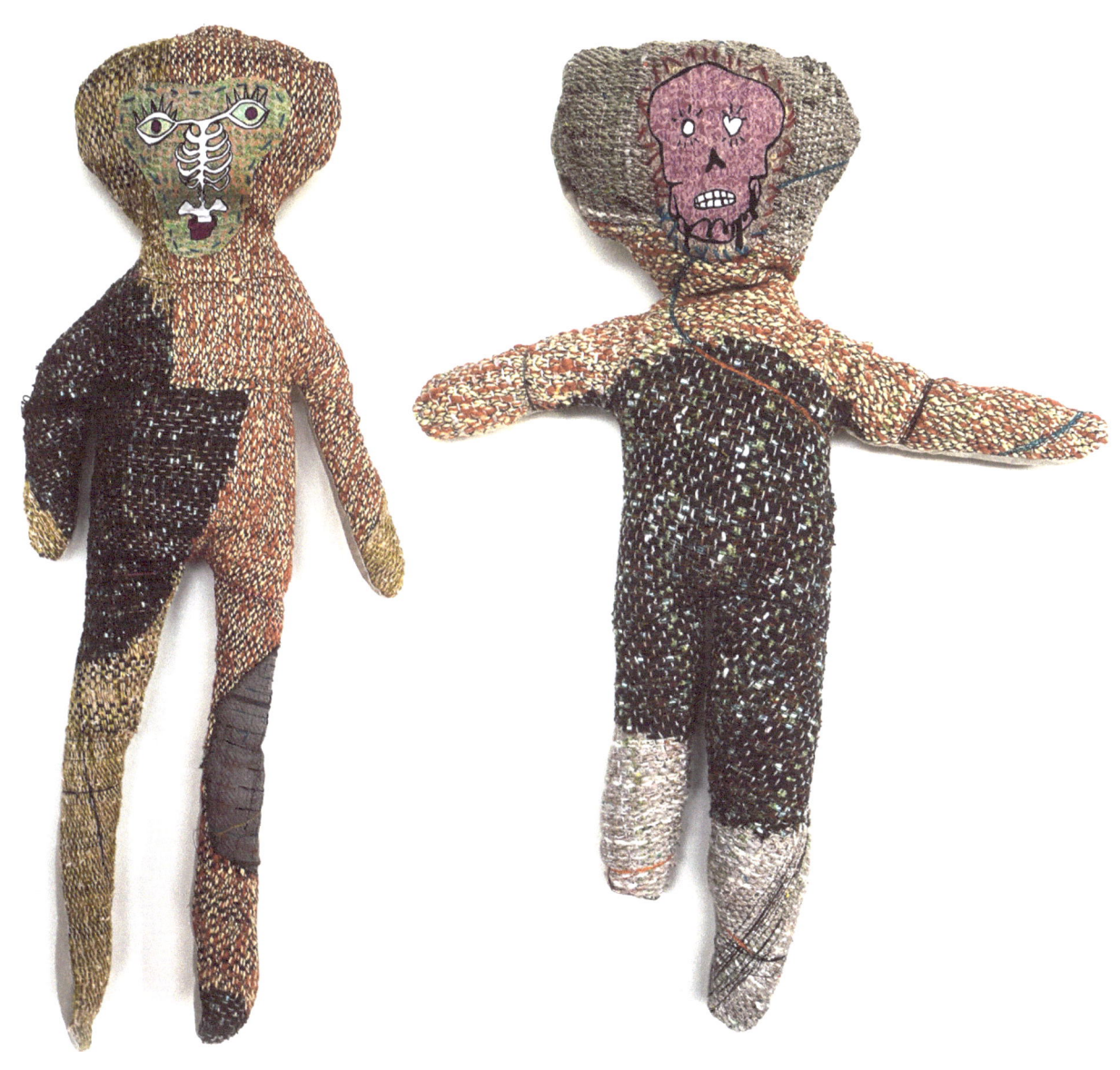

too pretty to eat

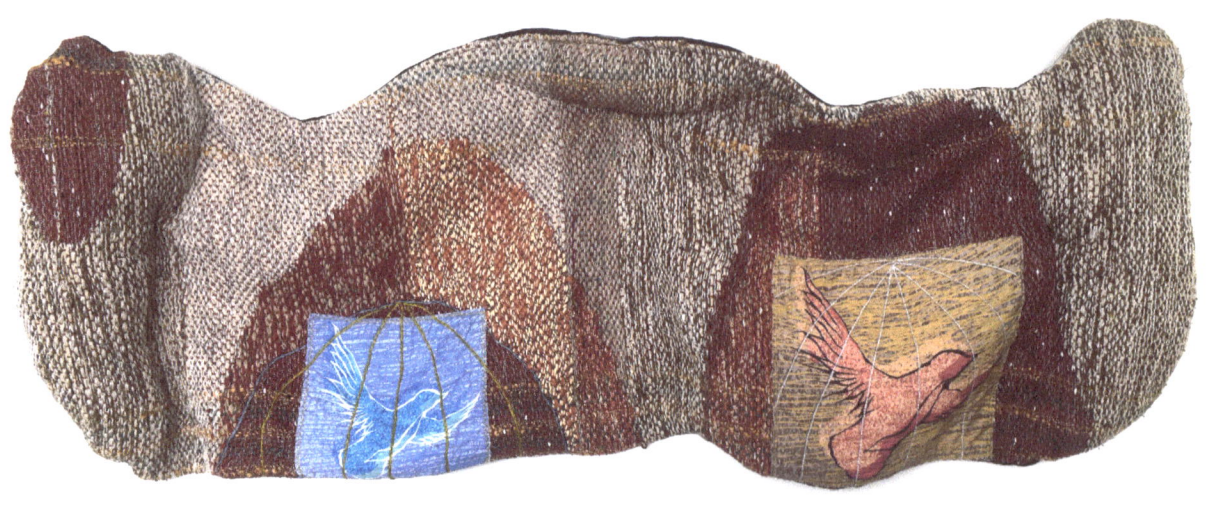

He kisses me ~~on the cheek~~ and ~~I feel like~~ I am falling.

~~What starts out as~~ a swan dive ~~ends up being~~ a belly flop.

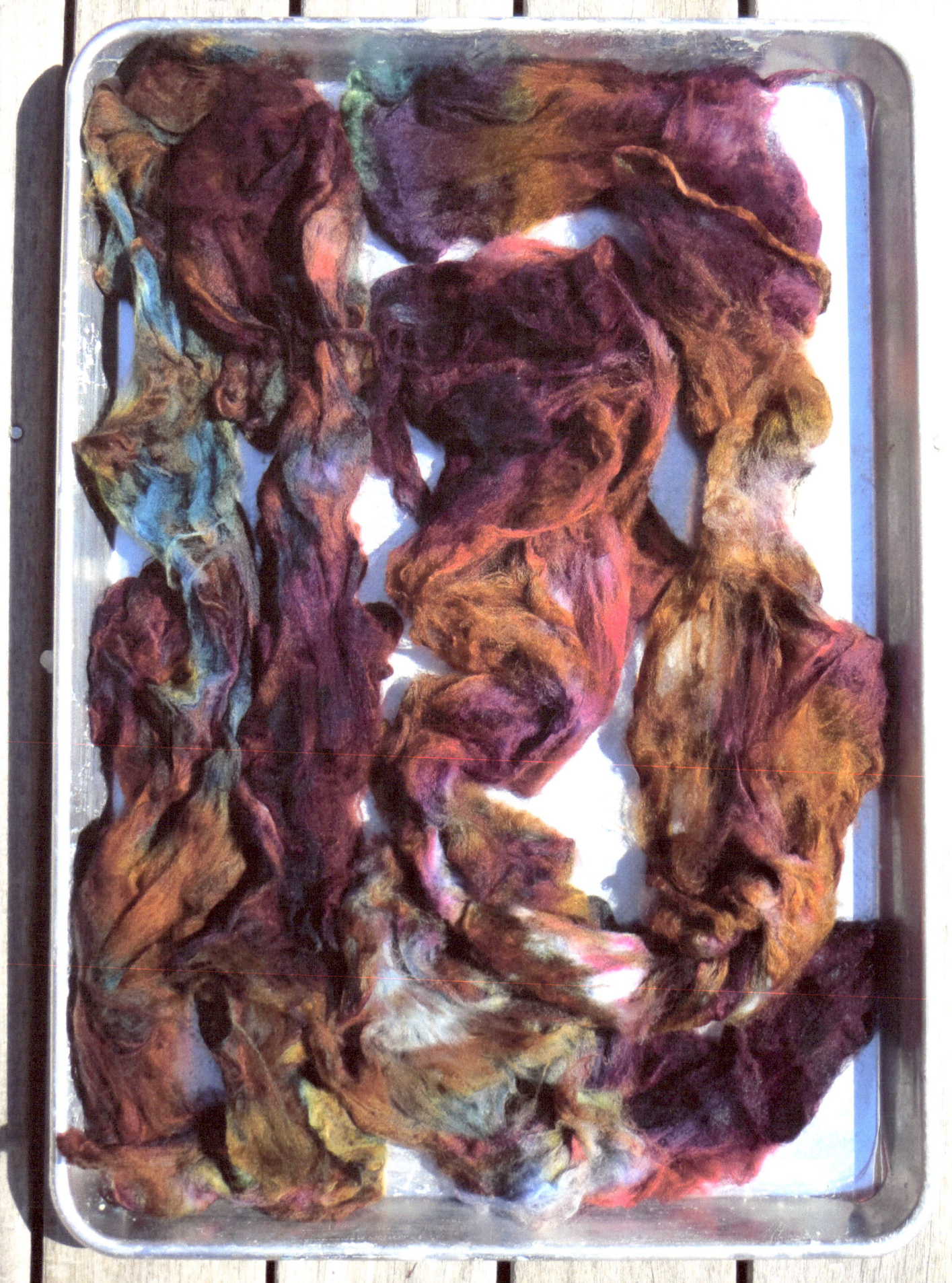

Kiss me ~~(and) on the cheek I feel like~~ I fall. ~~off a diving board.~~

~~What starts out as~~ a swan dive is a ~~being belly~~ flop.

I feel a little nauseous when he says I'm the only one.

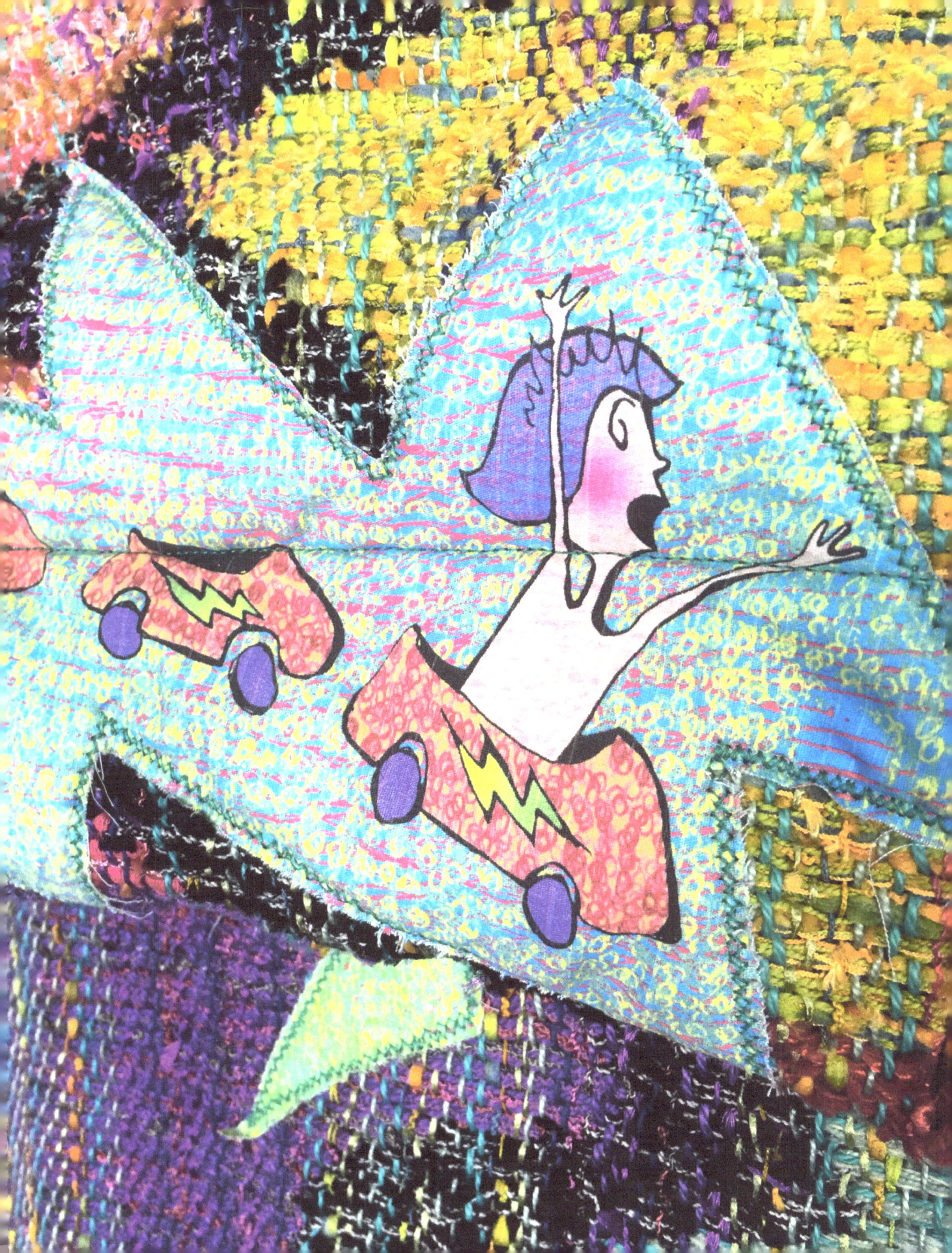

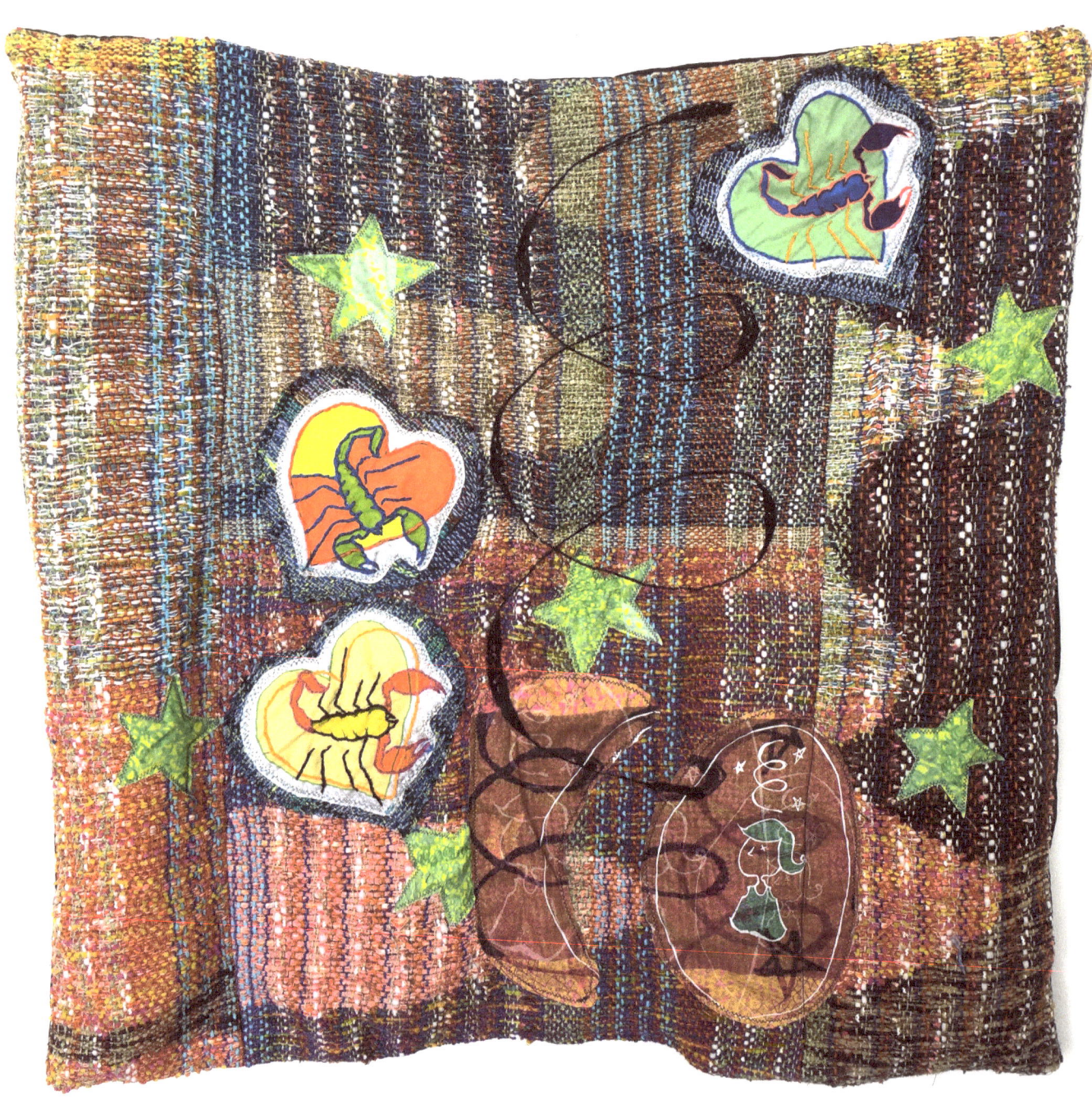

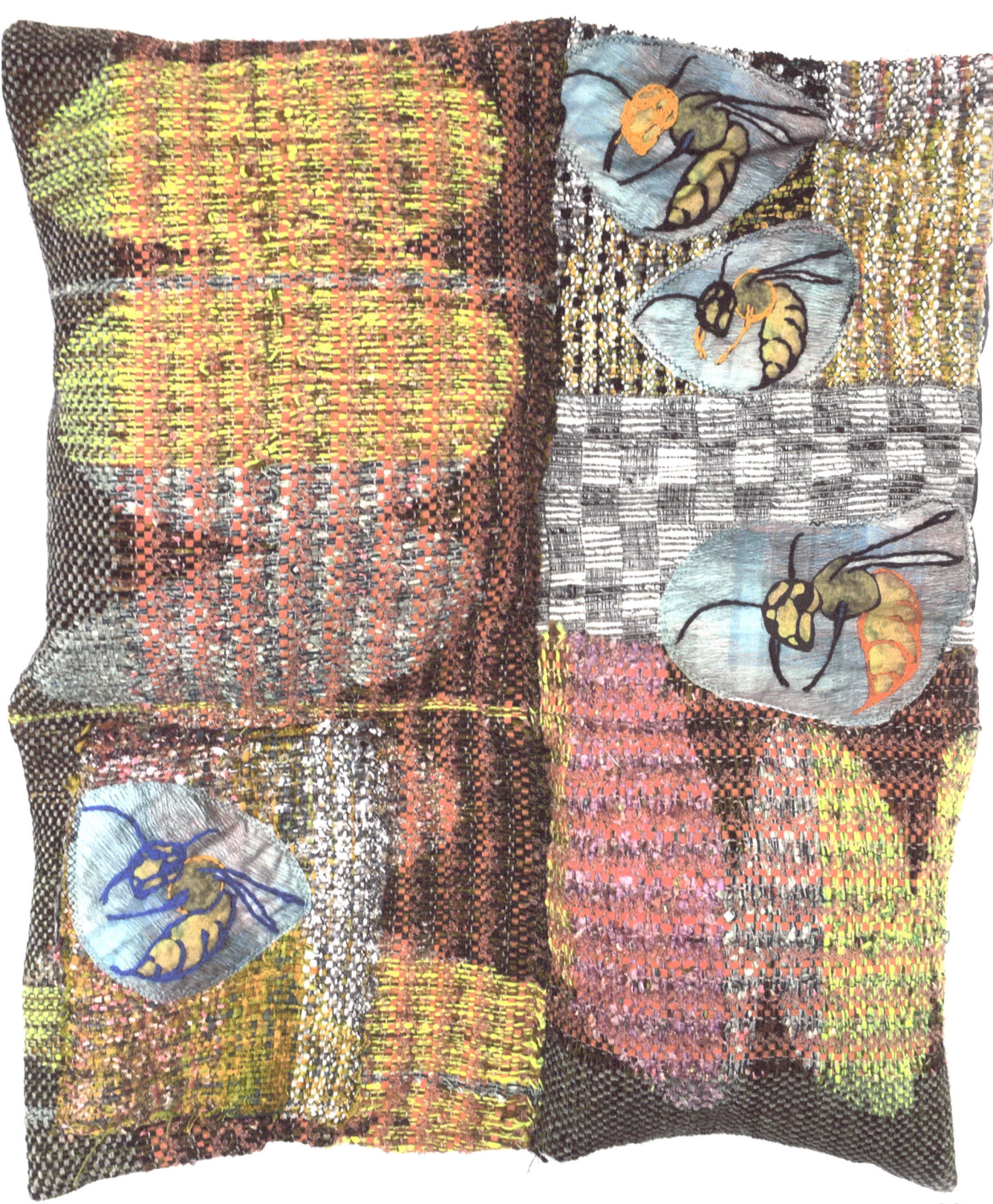

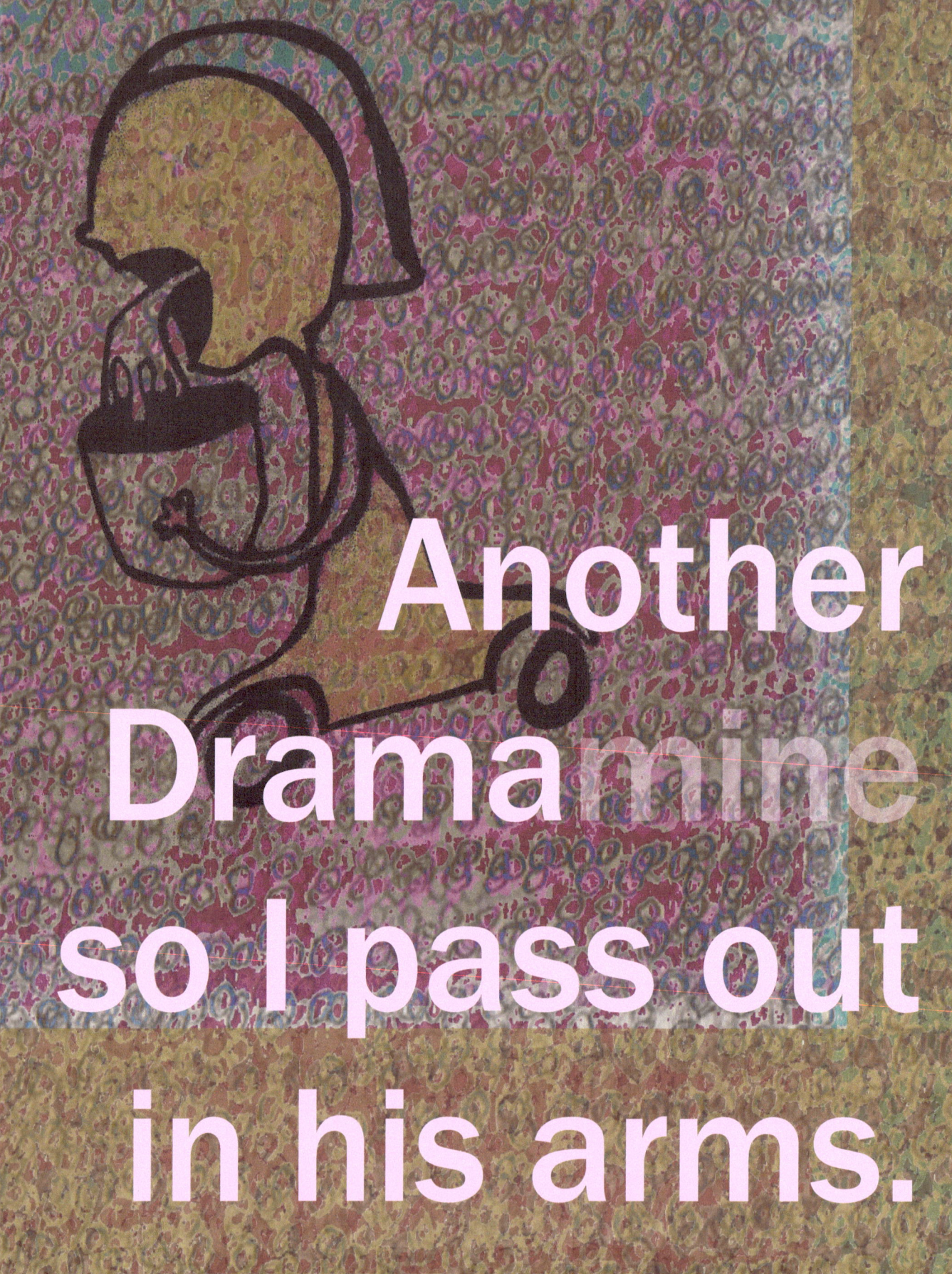

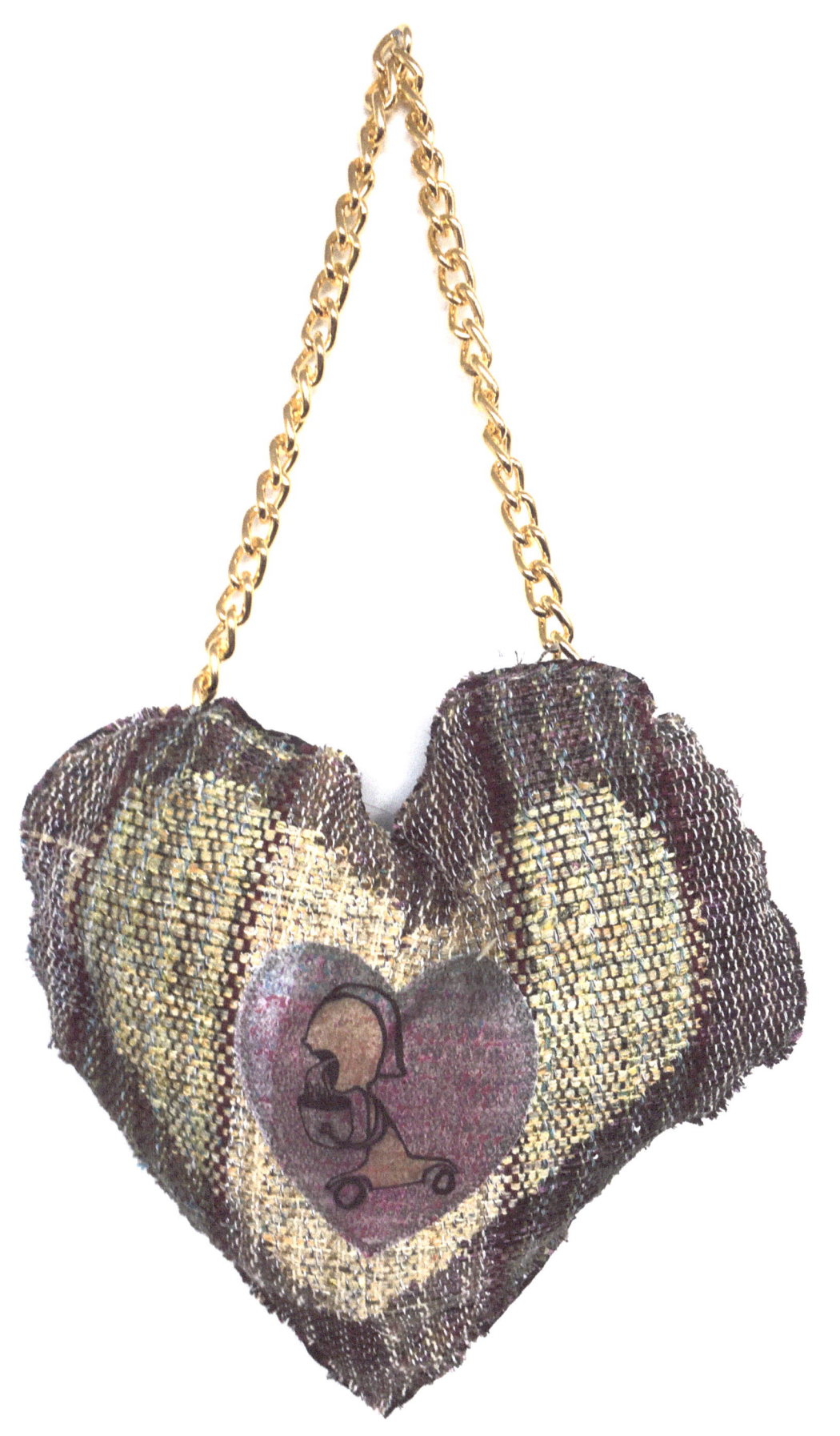

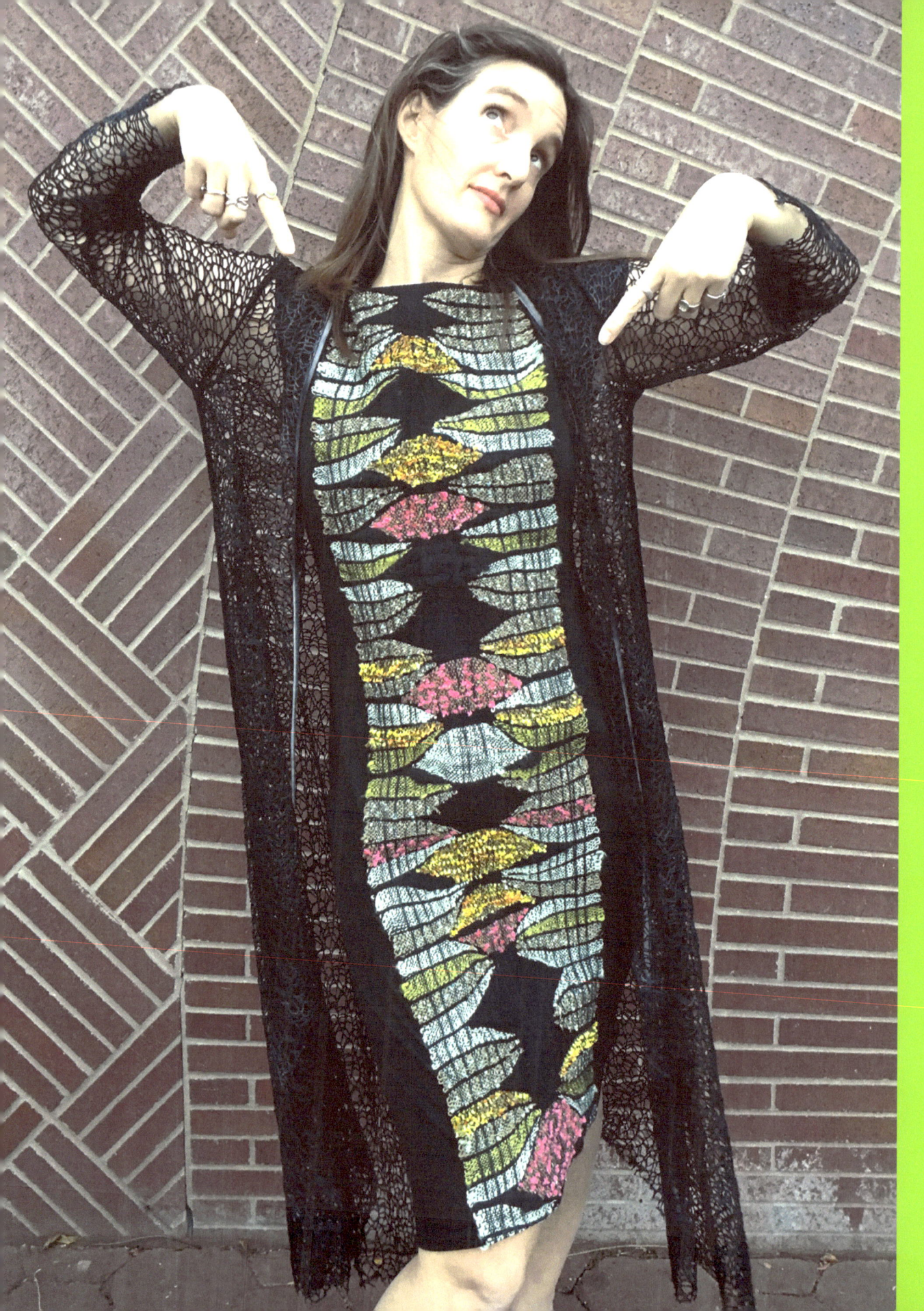

Not always funny, but always sincere.

(exhale)

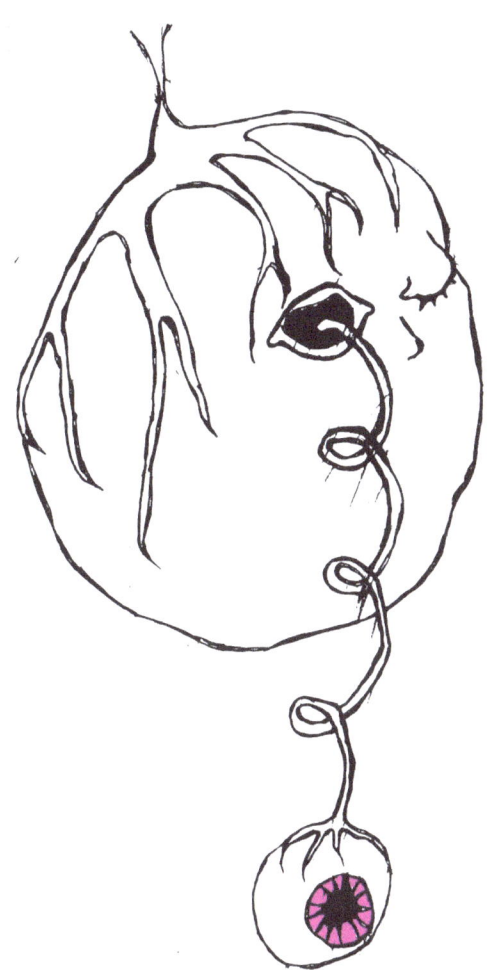

Thanks to you: **Josh Karpf**, Bob Martin, Ann Martin, Yukako Satone, Nobuko Tsuruta, Michiyo Shinohara, Maurine Packard, Marilyn Henrion, Marguerite Wolfe, Emily Rogers, Jonathan Warren, Laura Poll, Gail Elkin-Scott, Emily Stubbs, Leon Yost, Erma Martin Yost, an awesome weaver named Betty Vera, and Boot the Cat.

BA in Visual Arts from Brown University
MFA in Computer Art from the School of Visual Arts
Saori Weaver's Certification, Osaka

Work for this collection is in part from:
MASS MoCA Residency, North Adams, MA, 2017
Arts Letters & Numbers Residency, Averill Park, NY, 2016
Saori-no-mori, Osaka, Japan, 2015

Selected solo shows:
My Eyes Are Down Here, St. Peter's Gallery, NYC, 2017
My Eyes Are Down Here, Artworks Gallery, NJ, 2017
My Eyes Are Down Here, Sumei Arts Center, NJ, 2016
My Eyes Are Down Here, Belmar Arts, Belmar, NJ, 2016
I Would Wear That, Garrison Art Center, NY, 2016
Plight of the Art Mice, Creative Arts Workshop, CT, 2015
I Would Wear That, Noho M55 Gallery, NY, 2015
38 Voices in My Head, Saori Kaikan Gallery, Osaka, 2014
Men I Have Known, Artworks Gallery, NJ, 2014

This would have never *ever* happened if it wasn't for **M. Sweeney Lawless.**

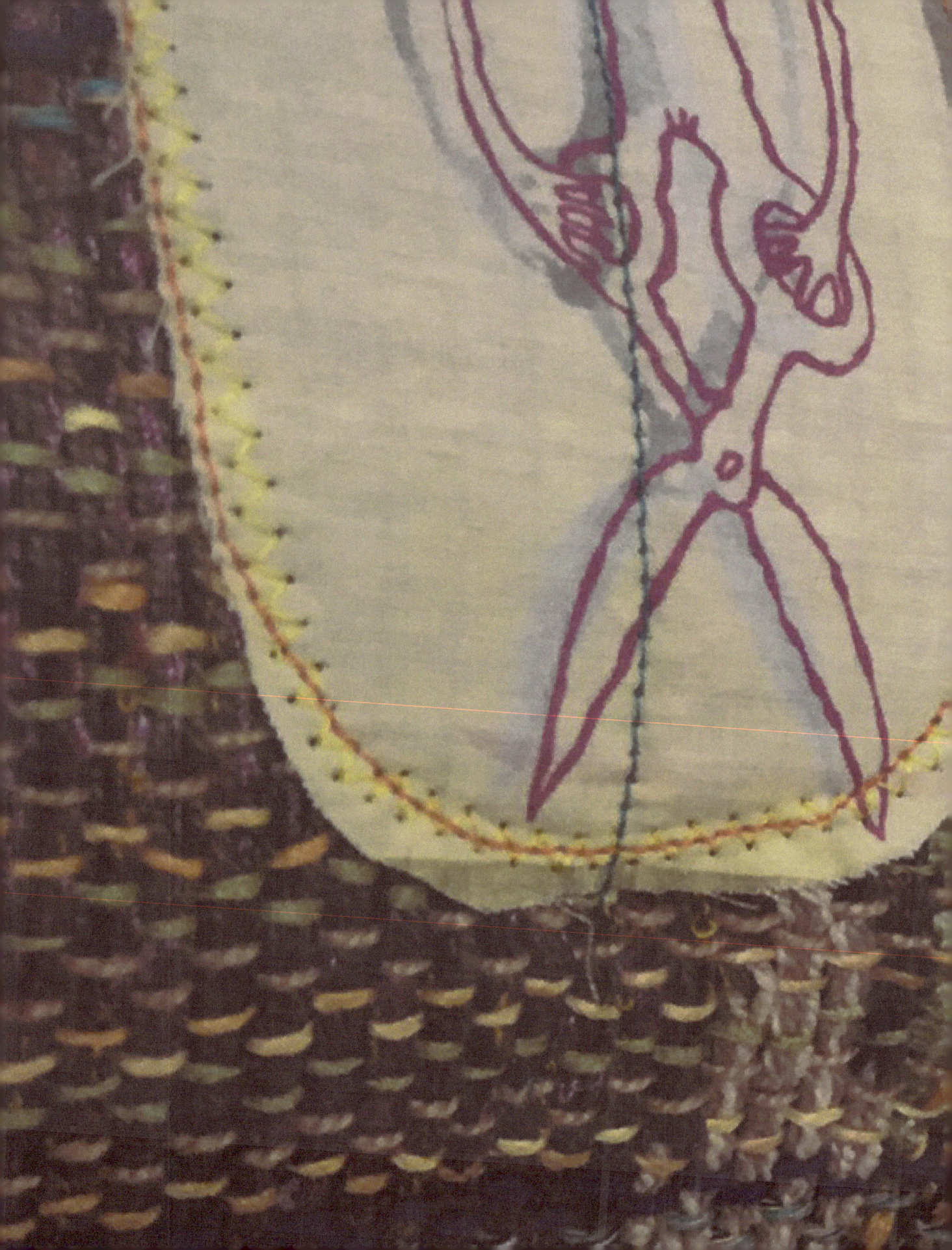

2, 7.
I Fell for You Three Times (purple)
H: 72" x W: 15"
Hand-woven and machine-made fabric, embroidery, inkjet prints, fleece
2017

12.
Killer Fish
H: 12" x W: 33"
Hand-woven and machine-made fabric, embroidery, inkjet prints, fleece
2017

15.
Brain Drain
H: 27" x W: 13" x D: 8"
Hand-woven and machine-made fabric, embroidery, inkjet prints, fleece
2017

19.
Eat My Feet (1)
H: 24" x W: 27"
Hand-woven and machine-made fabric, embroidery, inkjet prints, fleece
2017

21.
Spine Child
H: 28" x W: 12"
Skeleton Baby
H: 28" x W: 12"
Hand-woven and machine-made fabric, embroidery, inkjet prints, fleece
2017

22.
Like a Bird in a Cage (brown)
H: 13" x W: 39"
Like a Bird in a Cage (pink)
H: 17" x W: 26"
Hand-woven and machine-made fabric, embroidery, inkjet prints, fleece
2017

28.
Mixed Messages
H: 28" x W: 28"
Hand-woven and machine-made fabric, embroidery, inkjet prints, fleece
2017

29.
Love Stings
H: 26" x W: 22"
Hand-woven and machine-made fabric, embroidery, inkjet prints, fleece
2017

31.
Love Sick
H: 17" x W: 13"
Hand-woven and machine-made fabric, embroidery, inkjet prints, fleece, chain
2017

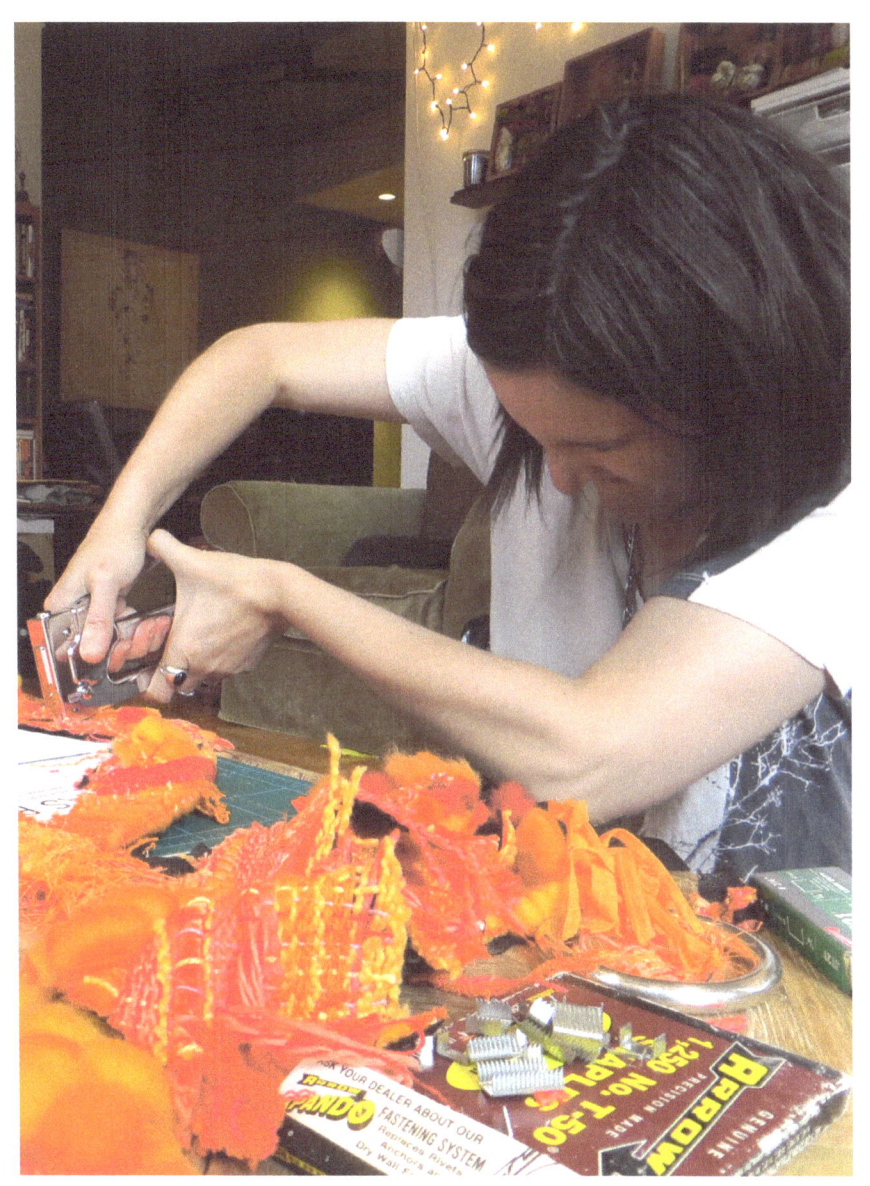

How it feels falling for you.

email: girl@julietmartin.com
web: http://julietmartin.com
cell: 646-220-8257

www.ingramcontent.com/pod-product-compliance
Lightning Source LLC
Chambersburg PA
CBHW041317180526
45172CB00004B/1137